HEDGEHOG
WISDOM

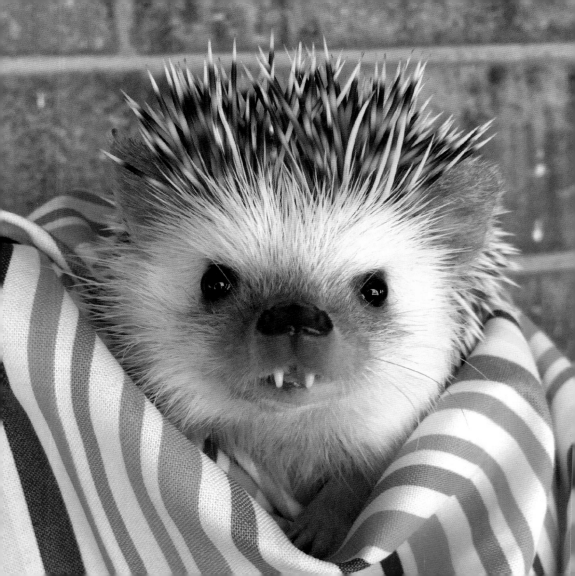

HEDGEHOG WISDOM

Little Reasons to Smile

Carolyn Parker

ROCK
POINT

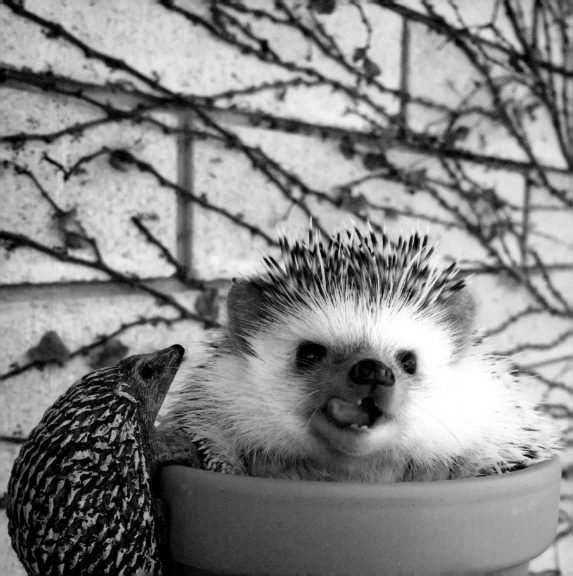

In Memory of
Hodge Huffington

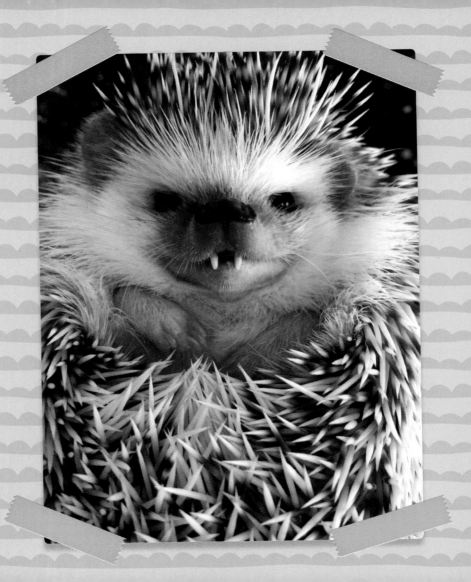

Enter the Hedgehogs

Hedgehogs are a lot like life: sometimes they're prickly and pokey on the outside, but all those sharp points hide a sweet, curious snugglebutt who just wants to be cared for. And once you get past the quills, you'll fall in love with the adorable personalities of these sweethearts.

The positive thoughts included in these pages will chase the clouds away and leave you smiling with every turn of the page. Read it straight through, browse it when you are in need of a little pick-me-up, and make sure you mark the pages that mean the most.

Ready for some fun? Let's meet the hedgies!

Meet the Hedgehogs

Hodge Huffington and Marshmallow Fluff are two African pygmy hedgehogs who want to help promote positivity and remind people everywhere to keep smiling!

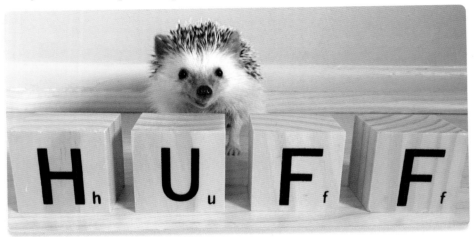

HODGE HUFFINGTON

After being left alone and in a tough situation, Huff found his happy forever home. Though he put up a grumpy front, this little hedgehog had so much love inside of him that he was able to make friends all over the world. Though Huff has passed on, his memory will live on through the smiles his pictures will forever inspire.

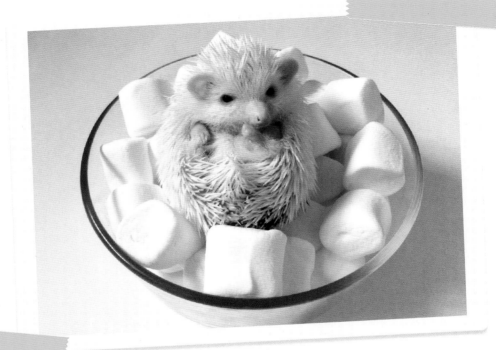

MARSHMALLOW FLUFF

Lover of nose rubs and perfectly timed runs on his wheel, Fluff is the tiniest ball of energy. He loves to wiggle, squeak, poo, and sleep . . . often at the same time. After a full day of adventuring, this little woodland creature will snuggle you so hard you won't ever want to put him down.

Being Yourself

You can't be everyone's cup of tea.

That's why I prefer my tea to be spiked.
It keeps the hedge—I mean the edge—off.
Be yourself and smile at the people who
love you for everything that you are.

NATURAL TALENT

Your talents are unique, especially
the weird ones.

Use your quirky gifts to bring a little
more color into your life and the lives
of the weirdos you love.

OPEN MINDS

Don't be sour when things don't go your way.
Just choose another path!

Preferably a path made of candy.
That'd be pretty sweet.

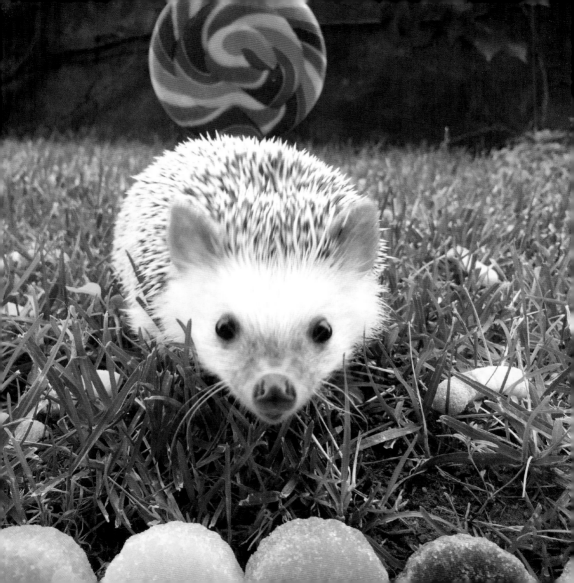

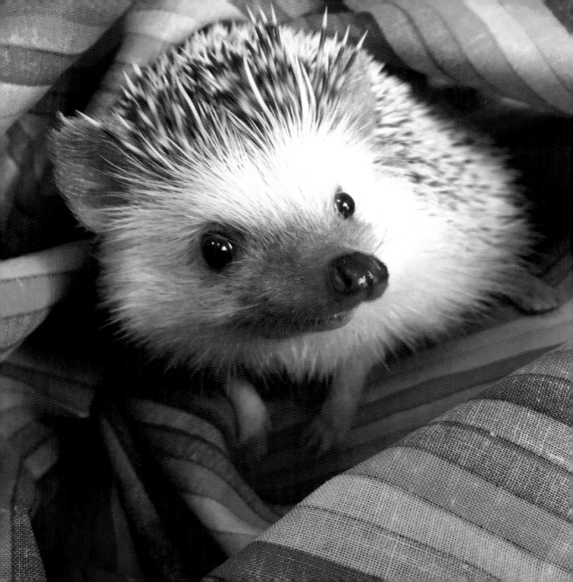

Helping Others

Make people smile!

Do a little favor for someone and it'll be
the biggest favor you do for yourself.
Your heart will be wrapped in a warm
rainbow blanket of happiness.

MINDFULNESS

Breathe.

In fresh mountain air or big city traffic jams . . .
Just remember to breathe.

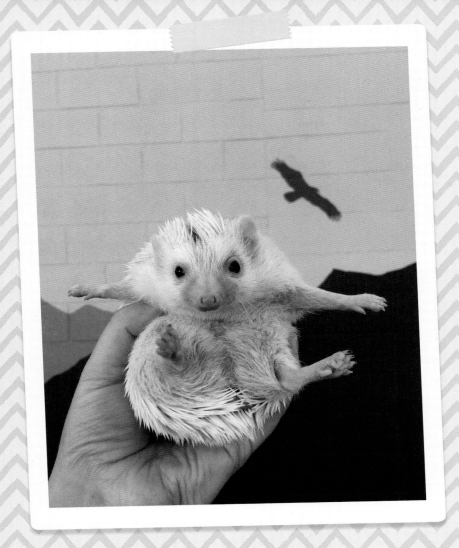

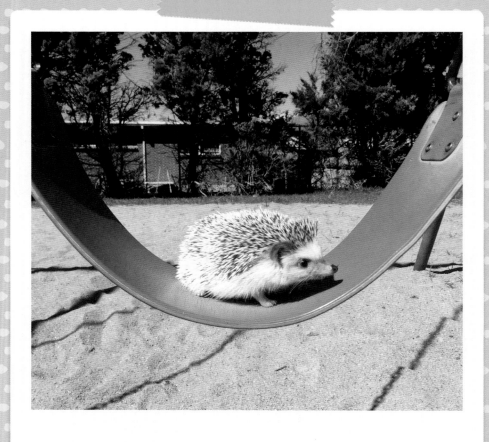

BRAVERY

Heights, the dark, social interaction . . .

Don't be ashamed of your fear,
and don't give it more power than it deserves.
Push through it and you'll see everything from
a different perspective. It might even be fun!

Laughter

Laugh at yourself, laugh at life, but refrain from laughing at other people.

Unless they are your best friend and your only form of communication is through loving insults.

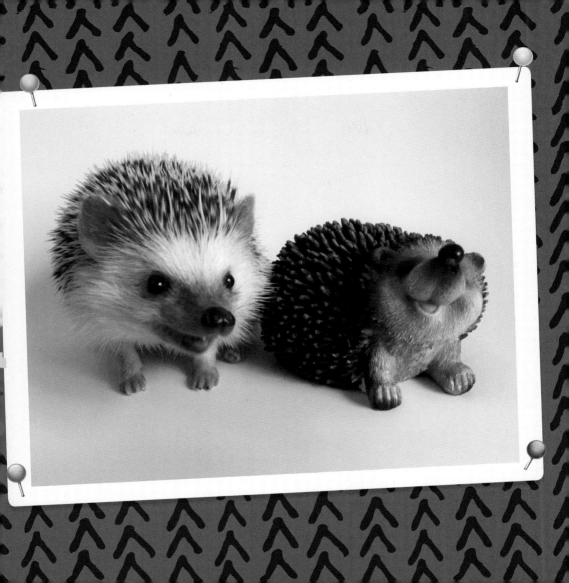

SELF-LOVE

You don't need a kissing booth to get self-positive affirmations.

"If you can get through a Monday,
you can get through anything!"
"You are THE best average-looking
person I know!"
"I am one hot potato!"

RELATIONSHIPS

Hold on to the ones who make you smile!

Their love is the sweetest—just add sprinkles!

Please don't eat them.

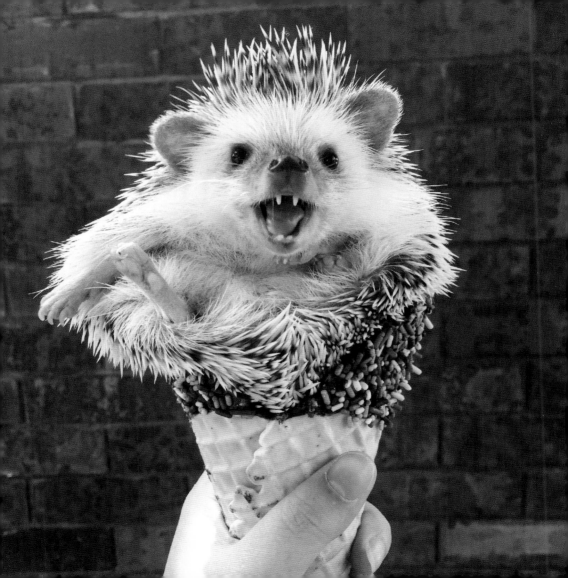

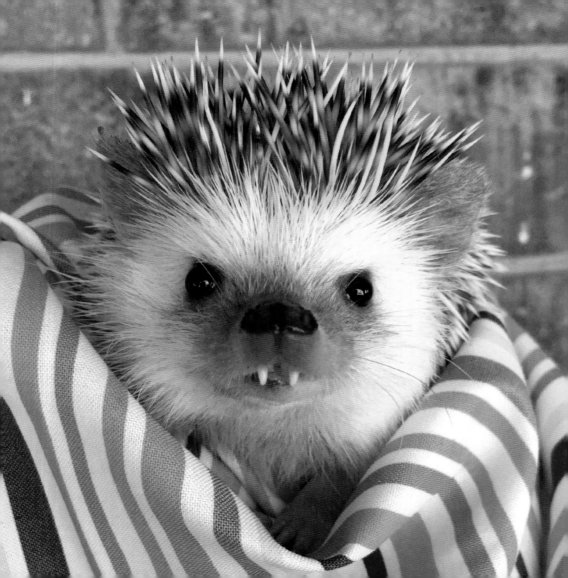

What Makes You Different?

Buckteeth? Skinny legs? Furry belly? Quills?

I guess we can't all have the perfect anatomy
of a hedgehog, but despite that,
you are lookin' sharp!

BEST FRIENDS

The best of friends are always there
when you need them.

Though in the case of snail friends,
they may always run (slide? gloop?)
a little bit late.

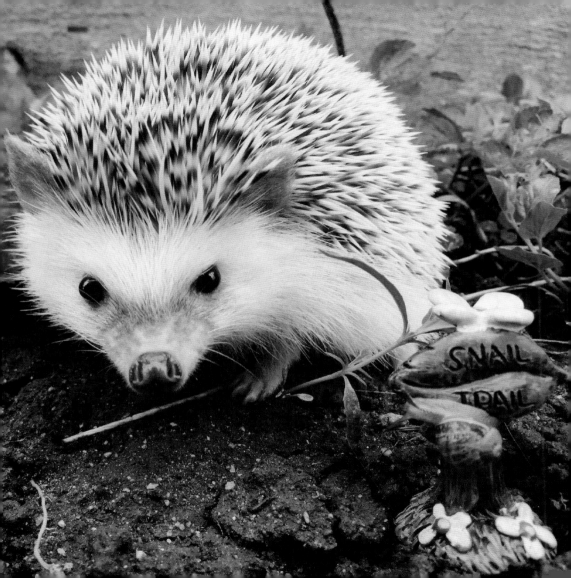

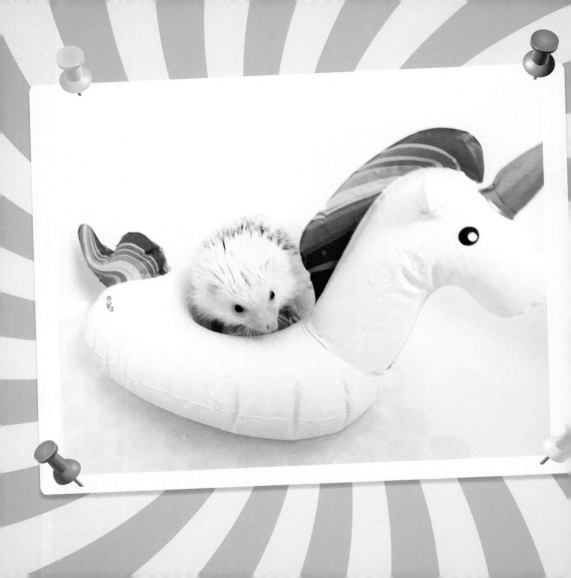

IMAGINATION

For when you want to ride
unicorns and fly to magical
lands where it's naptime all
of the time, except for when
it's snack time. Now that's
a true love story.

Achievements

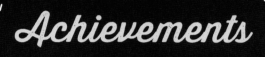

Celebrate!

You deserve to be celebrated
just for being you.
You are great and you deserve
a hedge-hug.

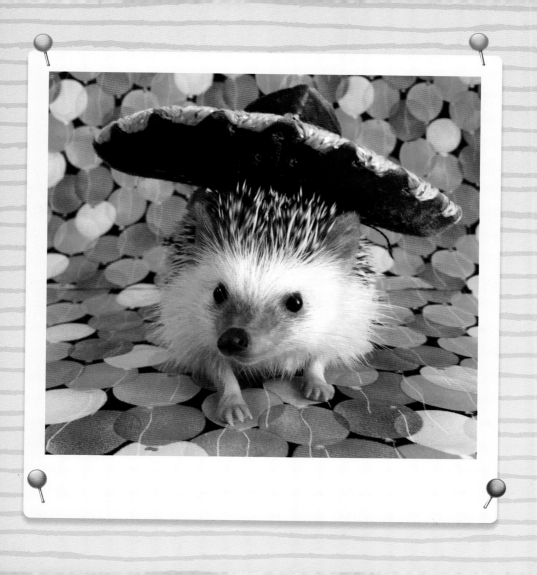

THE PERFECT FIT

Whether it be a new love or a new pair of jeans, you can find your perfect fit in the most unexpected, surprising places.

"How did I get up here?"

COOLING OFF

There's nothing like a dip in the pool and a juicy slice of watermelon to make a sweltering summer day into a fun time had by all. But hey, if you're tiny enough, why not enjoy both at the same time?

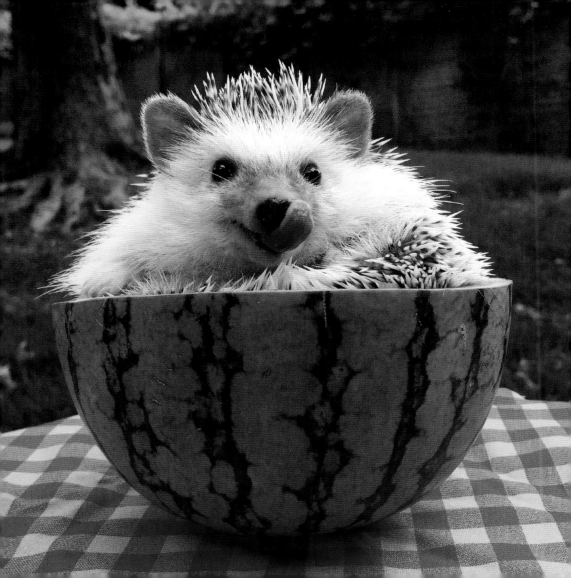

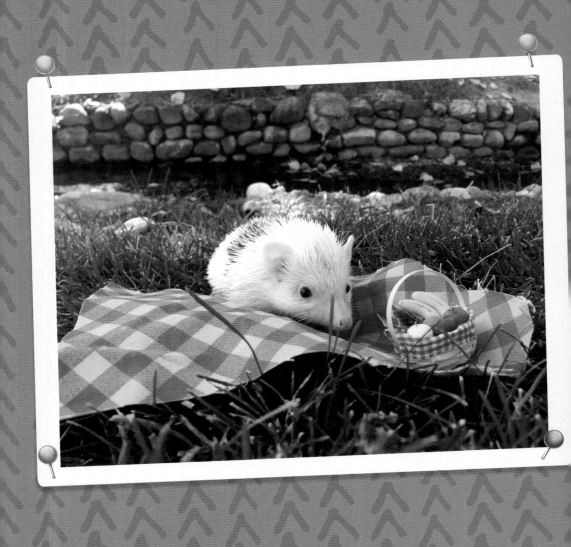

PICNICS

Most people think it's ants you have to watch out for while enjoying a wonderful picnic lunch.

But the worst sandwich thieves are the kind with four legs, prickly quills, and curious little noses!

Learning New Things

When hedgehogs encounter a strong smell or taste, they will often take a bite of it and then lick their quills all over. No one knows why they do it.

There, now you know a new thing!

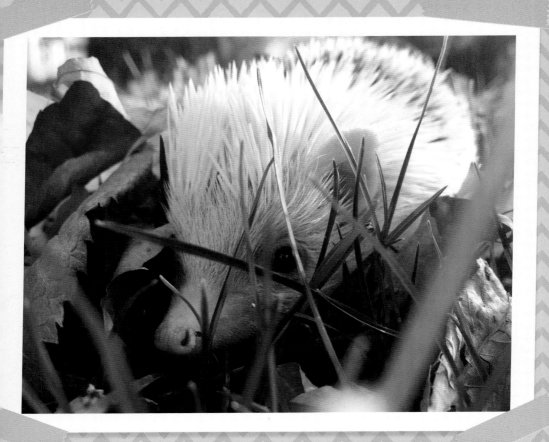

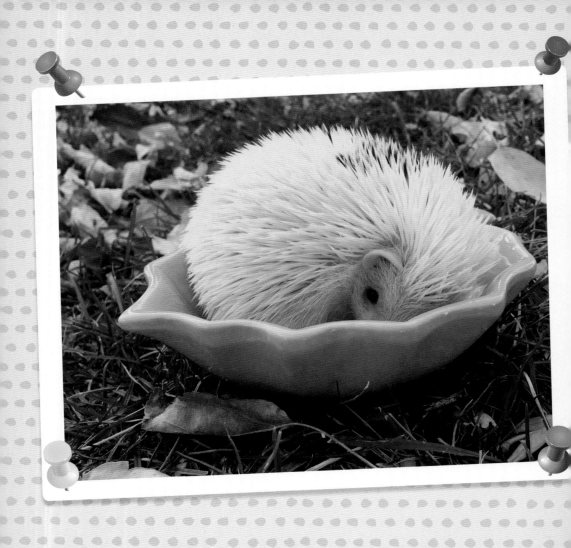

LIVING YOUR TRUTH

Come out of your little ball!

Don't be nervous to open up
and express yourself.
Forget the expectations and definitions and
instead remember who you truly are.
(Hint: Pretty freaking awesome!)

DREAMING

That fleeting feeling between being wide
awake and dreamland, the peaceful calm
where your dreams and reality merge
into one happy little moment.

Remember all of the happy little
moments, no matter how small.

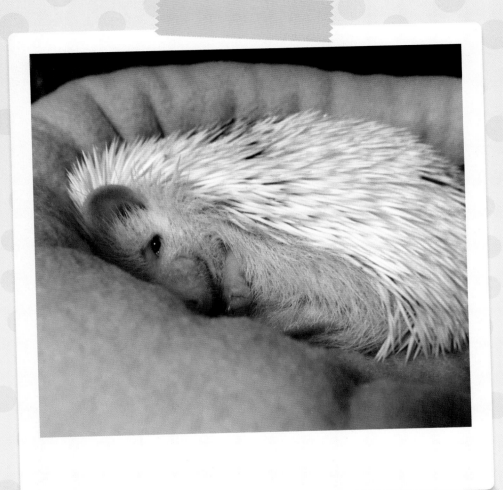

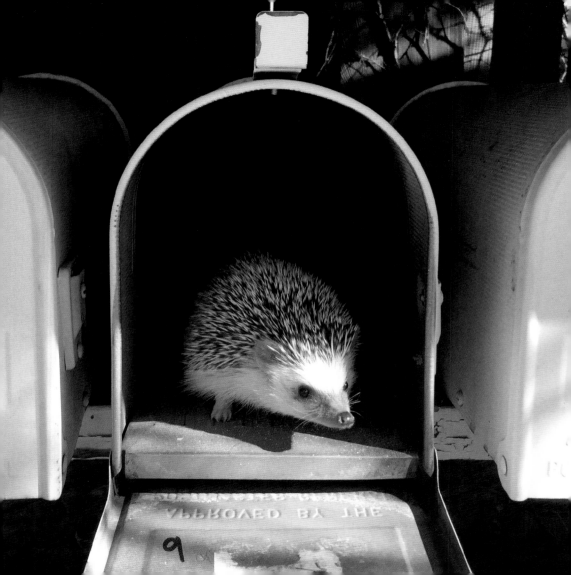

Letters

Handwritten letters are gifts from our favorite people. Be someone's favorite and write them a letter!

PS. Quill pals are better than pen pals.

LAKE DAYS

Take a "sick-of-work" day and
catch some sun, fish, and Zs!

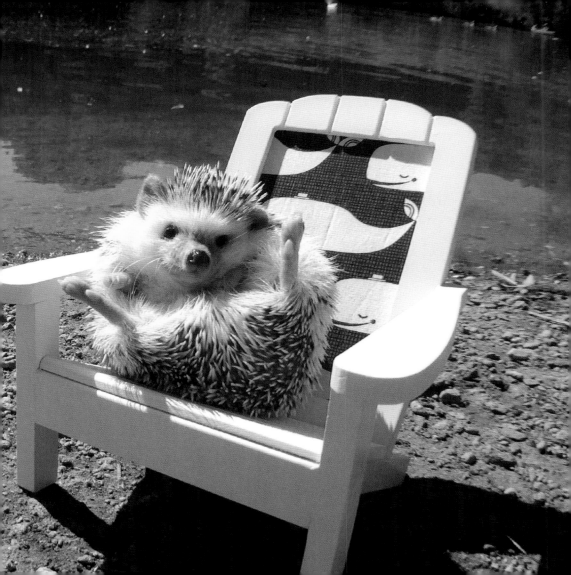

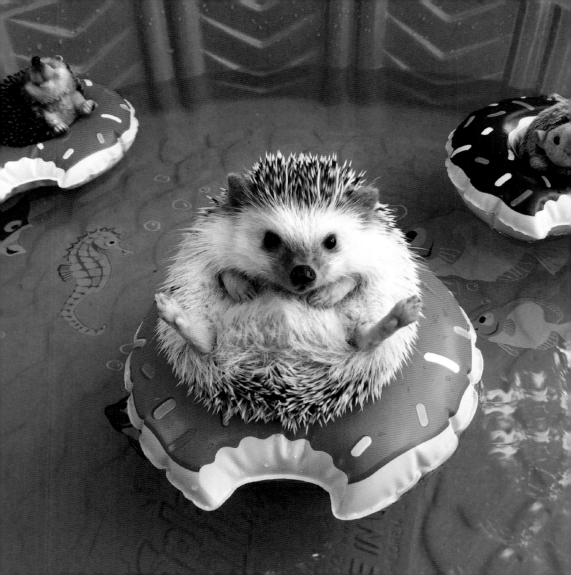

POOL PARTIES

Pool parties are awesome for kicking up
your feet and relaxing in a tiny donut float.

It's even better when you invite
your quilly crew!

Naps

When people try to tell you that laziness is a negative personality trait, just say,

"Shh! I'm napping."

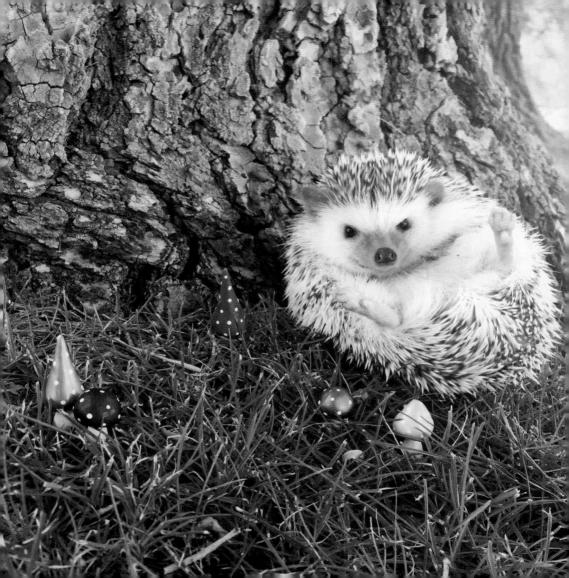

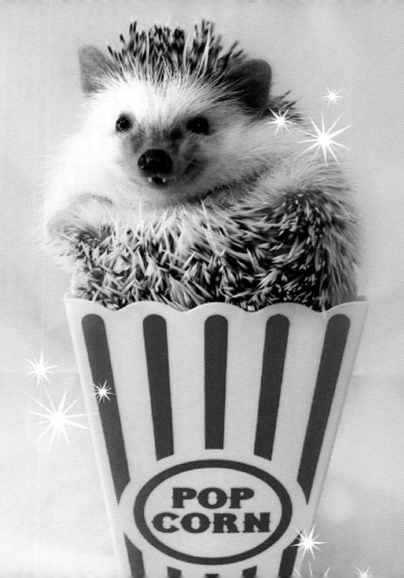

MOVIE NIGHTS

Even though it sounds corny
(Huh? Get it?), we must be the
lead in our own lives.

Be the hero. Be the romantic interest.
Be the comic relief.
Just . . . be you!

ADVENTURE DAYS

For the basic hedgehogs who just
want to live their best lives.

In Huff's case, his best life includes
cowboy hats and riding tiny
imaginary horses. Yeehaw!

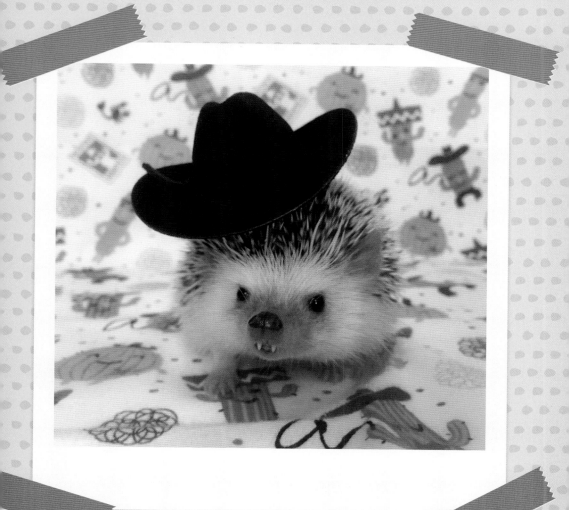

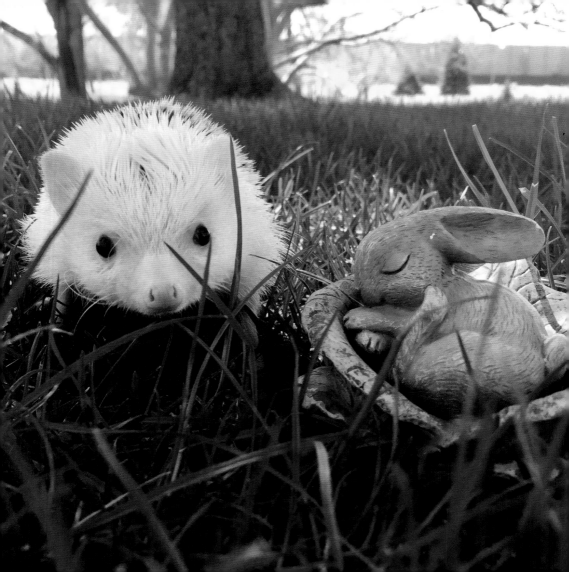

THE OUTDOORS

If you're feeling cooped up and stressed out, it might be time to calm down and get out!

Though hedgehogs are nocturnal, they enjoy a bit of sun as much as the next creature.

Gardening

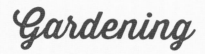

When you can't find happiness,
plant happiness. Or in this case, if you
can't find a plant . . . be the plant!

This is a new plant species
called the *Hufflepot*.
It's very rare.

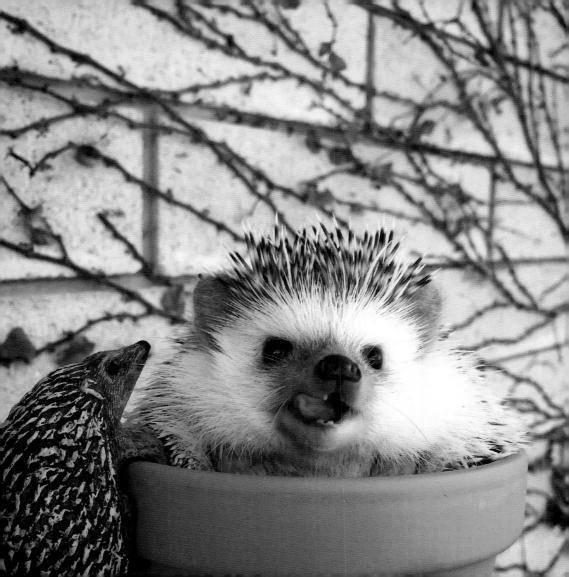

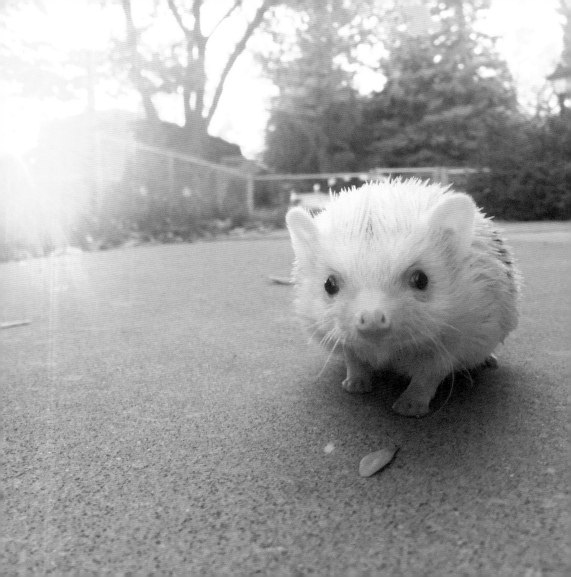

SUNSHINE

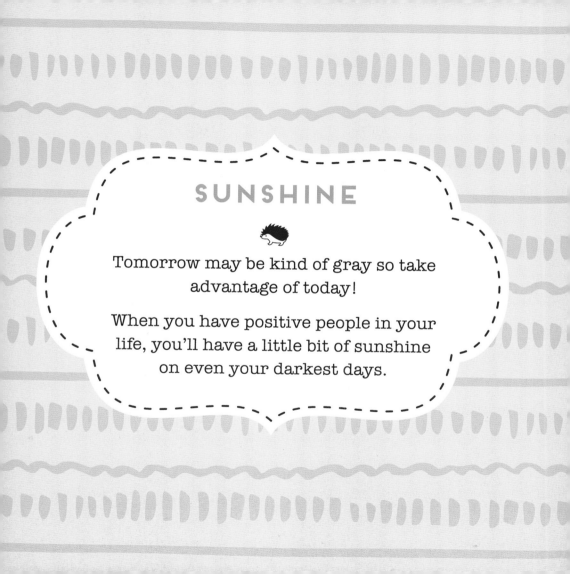

Tomorrow may be kind of gray so take advantage of today!

When you have positive people in your life, you'll have a little bit of sunshine on even your darkest days.

TRAVELING

As you discover new places and experience new things, you also discover new things about yourself. You may even find that mealworms are your new favorite snack! Mmm, tasty.

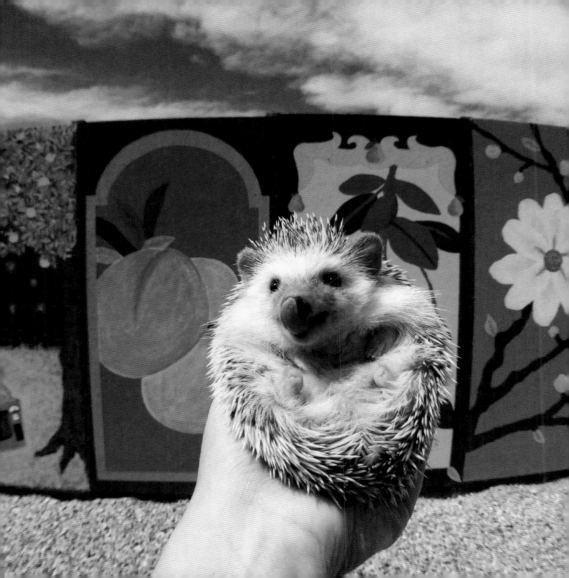

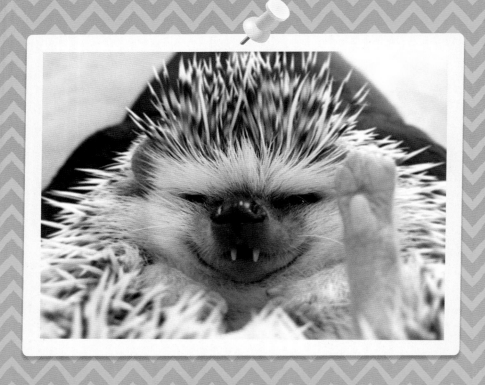

ALL TUCKERED OUT

Whew! There's only so much outdoor activity one little hedgehog can take before he's completely pooped and needs a breather.

Huff's not going to take a nap or anything, he's just going to . . . rest his eyes . . . for a minute . . . Hedgehog tip: Take a little nap if you need it!

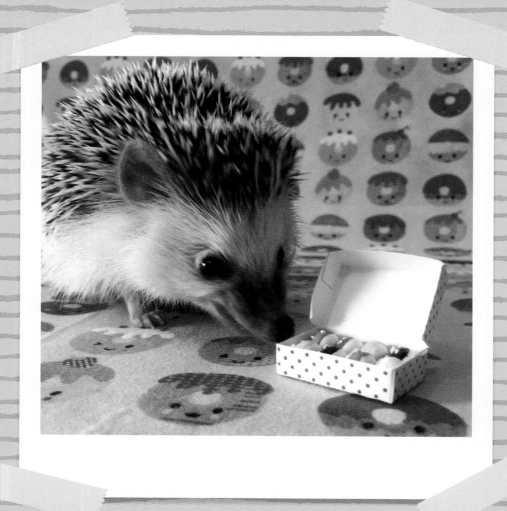

Food

Eating your feelings isn't the
healthiest way to go, but it is
definitely the tastiest!

Just be sure to work out your feelings
with some exercise later.
Balance is important . . . I guess.

TACO TUESDAYS

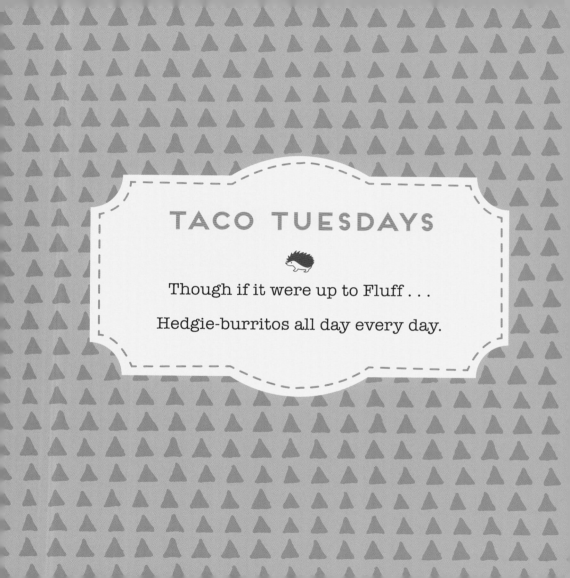

Though if it were up to Fluff . . .

Hedgie-burritos all day every day.

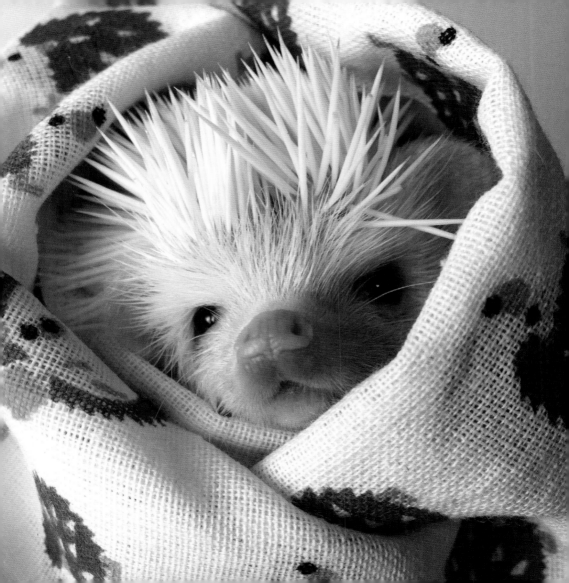

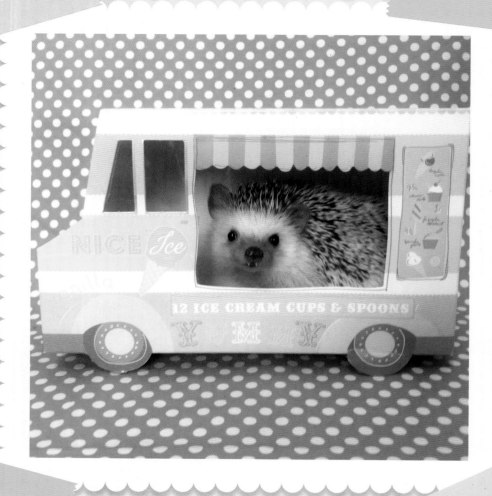

ICE CREAM TREATS!

Huff 'N' Fluff's most popular flavors are
Pokey Peppermint, Cookies and Quills, and
Crunchy Cricket (a hedgehog delicacy).

Donut Worry

Worrying is twice the trouble.

Instead, be proactive in focusing
on what could go right!

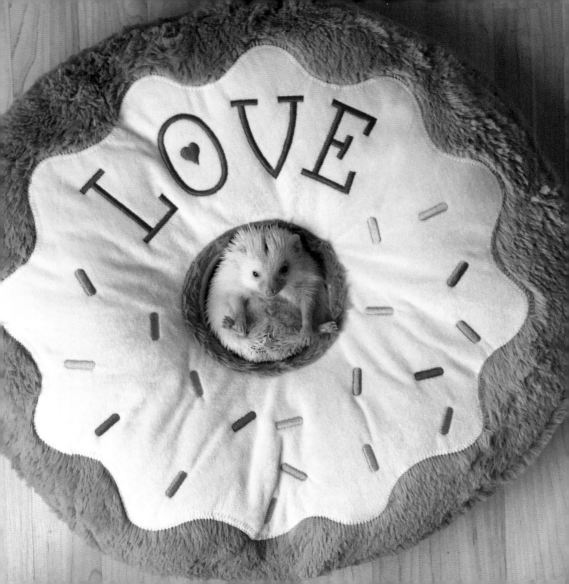

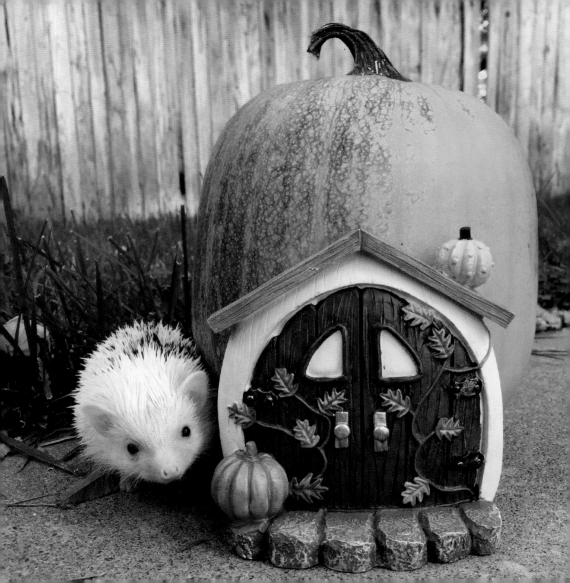

ALL THINGS PUMPKIN

Have you heard of pumpkin fairy dwellings,
enjoyed by hedgehogs and fairies alike?

They throw little parties and
use pumpkin seeds as plates! It's adorable.
We all have to believe in something—
why not fairies?

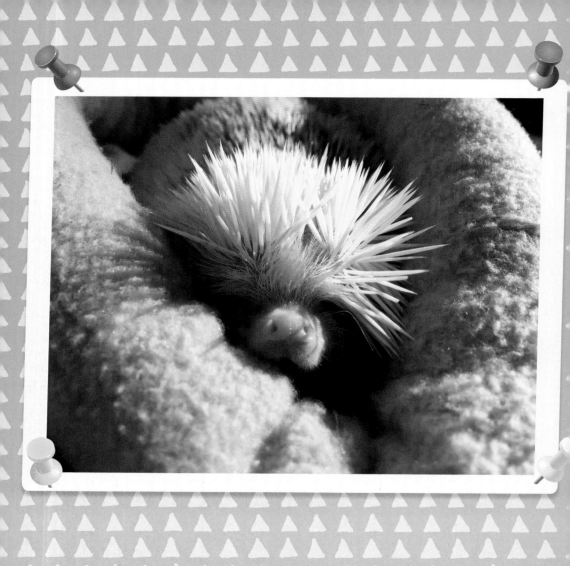

BAD DAYS

Everyone has them—especially if
you're a natural grump.

Be thankful for the bad days
because they make the good
days that much better!

Bad Hair Days

If your style includes rocking
bedhead at all times, rock on!

A bad hair day never hurt anyone.
I mean, probably not. I don't know
the statistics.

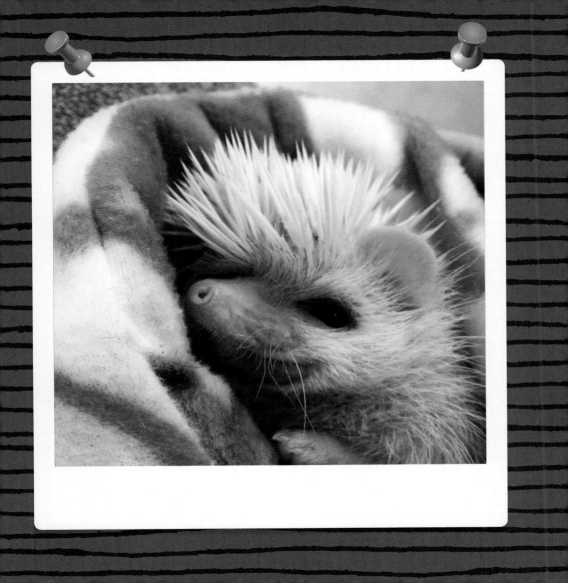

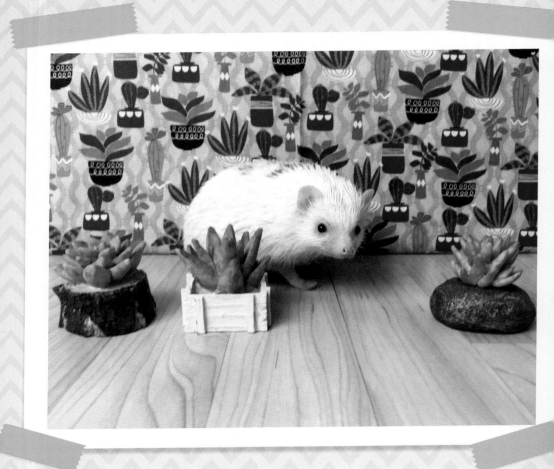

VULNERABILITY

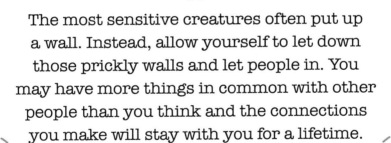

The most sensitive creatures often put up a wall. Instead, allow yourself to let down those prickly walls and let people in. You may have more things in common with other people than you think and the connections you make will stay with you for a lifetime.

HARD TIMES

When things get tough, just
remember one thing:

You are tougher than your problems.
You rock!

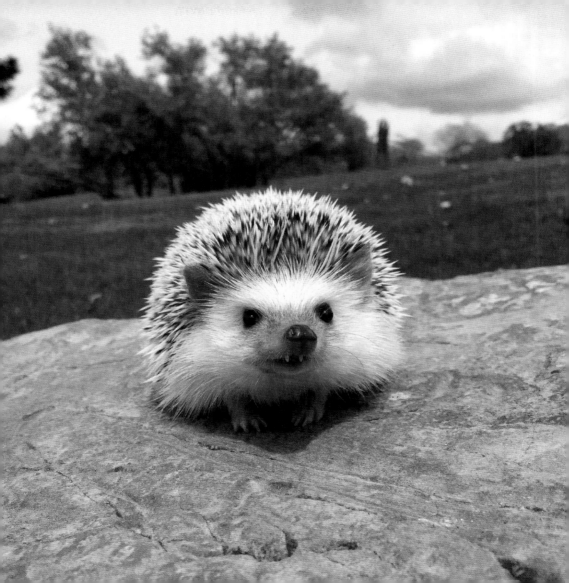

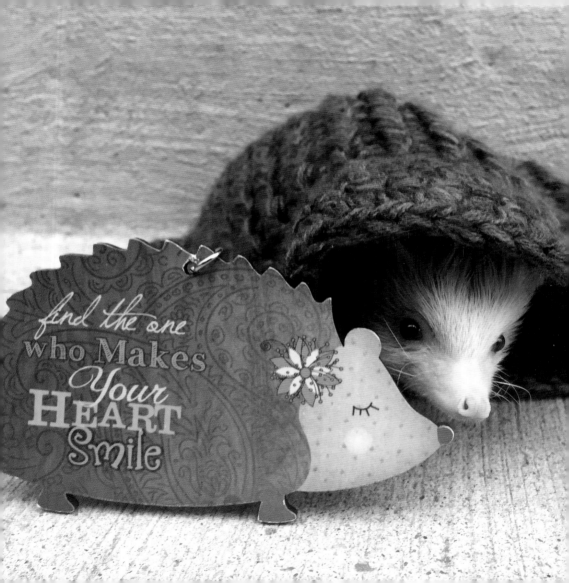

Comfort Zones

Whoever said it was good to get out of your comfort zone obviously didn't have a cozy enough blanket.

RAINY DAYS

They are the best for
rolling into a ball of emotion
or wearing organic umbrella hats.

I would recommend both.

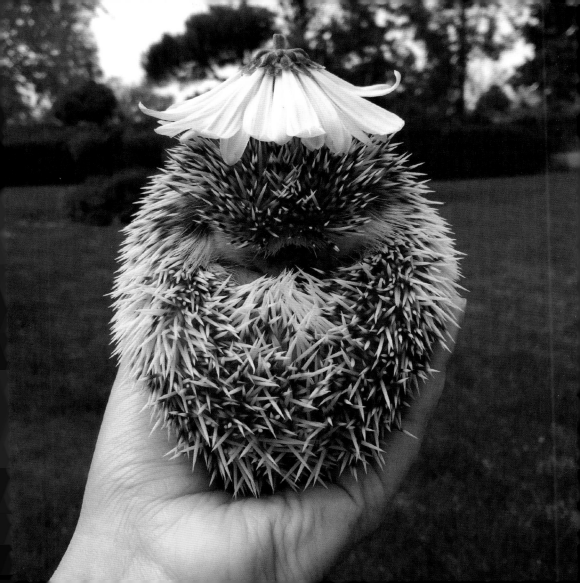

LAZY DAYS

Hedgehog and Chill!

Obsessing over a new series from the
comfort of your little couch is *everything*.
Just don't hog the remote.

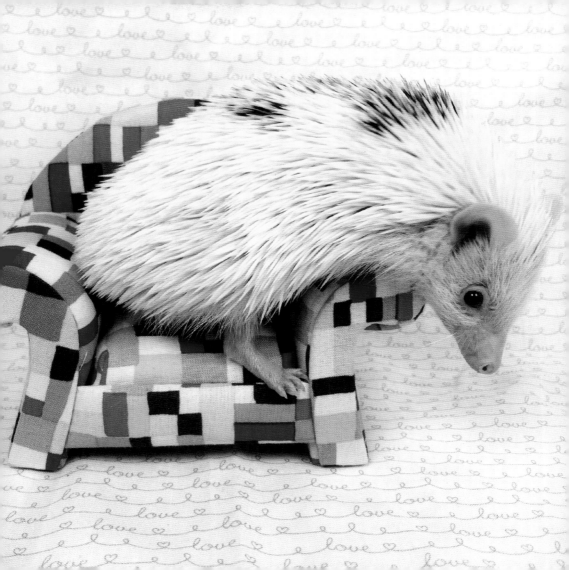

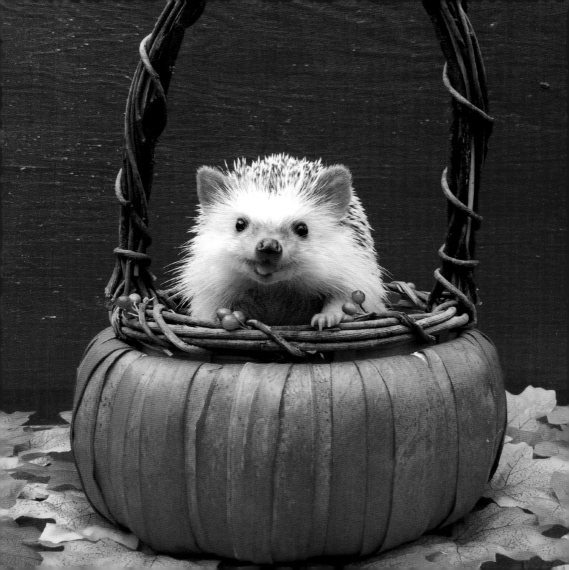

Change

Change can often come out of
nowhere, be a bit rude, and yet be
beautiful—just like a leaf.

HOPE

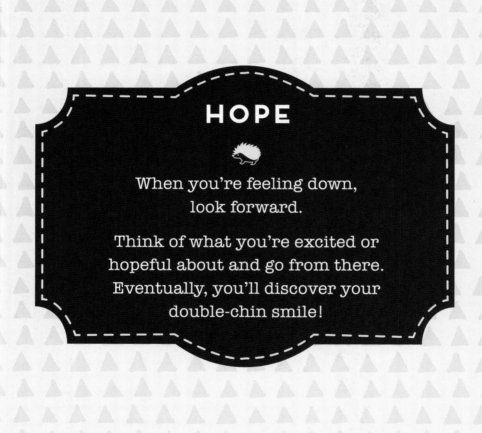

When you're feeling down,
look forward.

Think of what you're excited or
hopeful about and go from there.
Eventually, you'll discover your
double-chin smile!

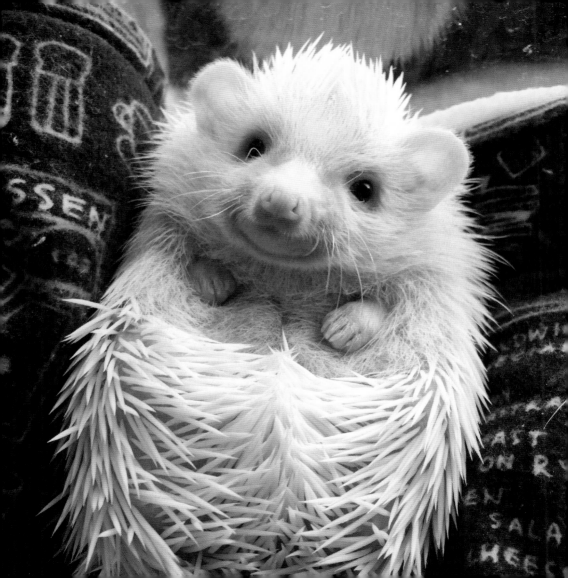

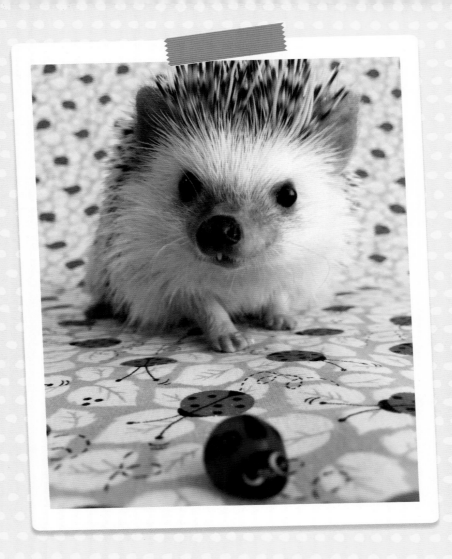

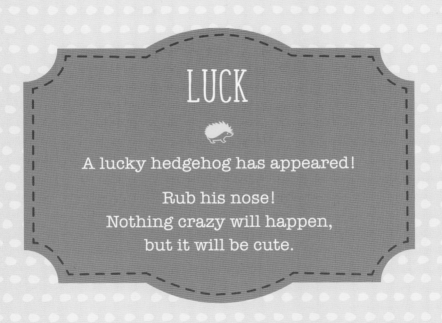

LUCK

A lucky hedgehog has appeared!

Rub his nose!
Nothing crazy will happen,
but it will be cute.

Flowers

How does that saying go again?

Stop and smell the hedgehogs!
Uh, close enough.

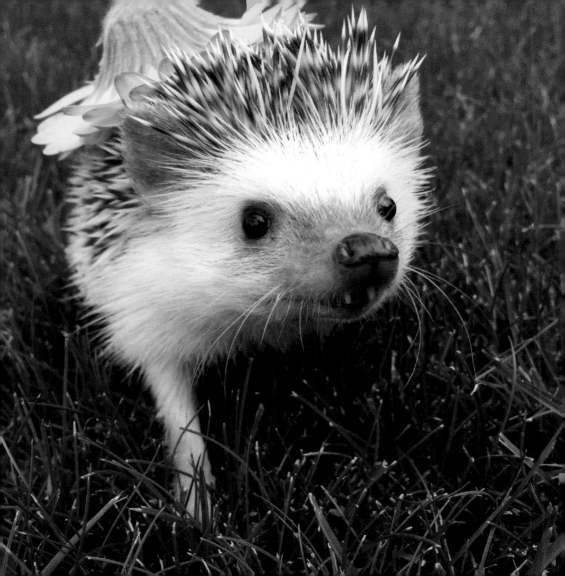

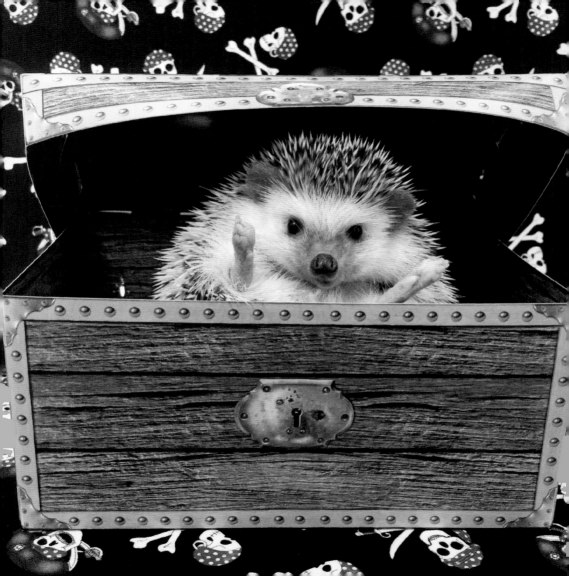

TREASURE

Treasure can mean different things
to different people.

One of the best treasures involves pirates and
actual money that you can buy things with.
For instance, books about hedgehogs
(hint, hint).

BIRTHDAYS

Whatever worries you have about growing
older, just remember that nothing can be
that bad if balloons are involved.

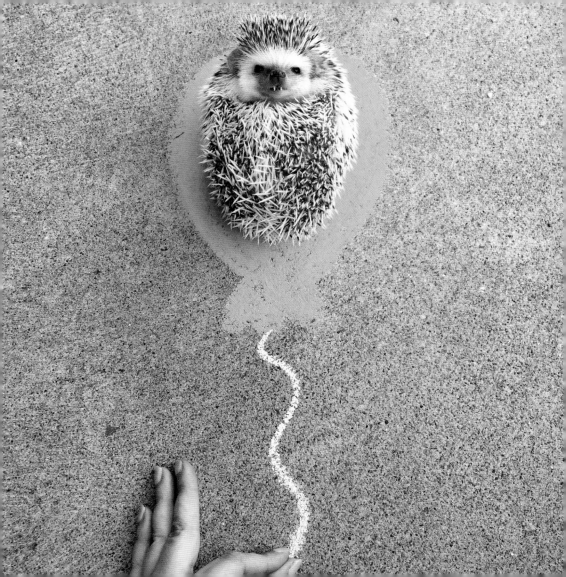

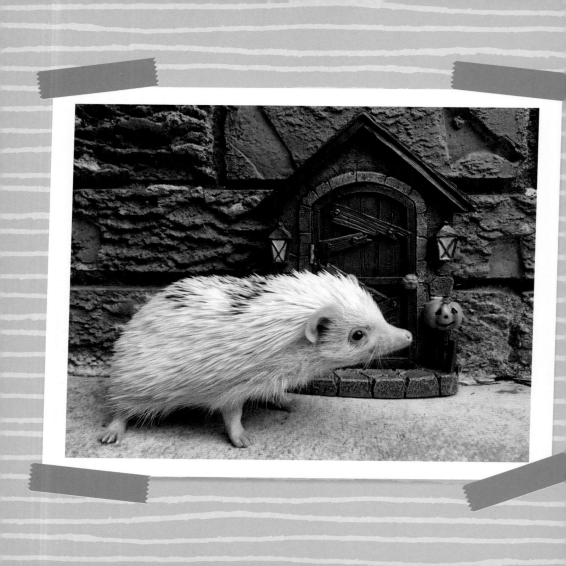

Positive Vibes Only

When one door closes, it's fine, because you don't need that kind of negativity in your life. Especially if the door leads to a haunted house.

No thank you, please!

SNOW

If you can forget the fact that it's
unbearably cold, messy, and otherwise
unpleasant, it has a funny way of bringing
people together—whether for the holidays
or for some much-needed warmth.

A hedgehog is the perfect cuddle buddy!

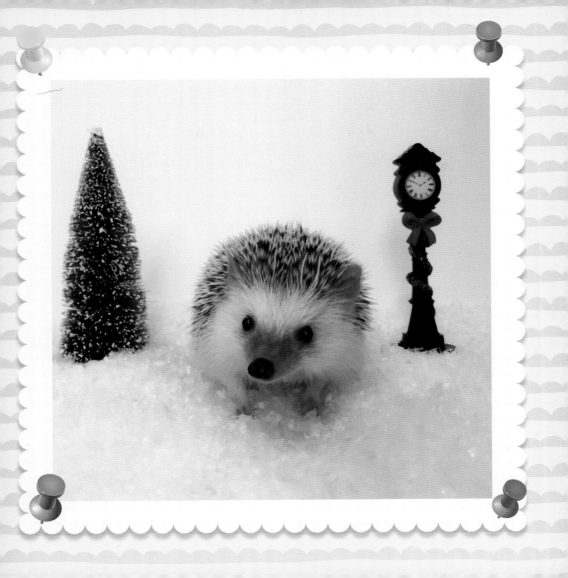

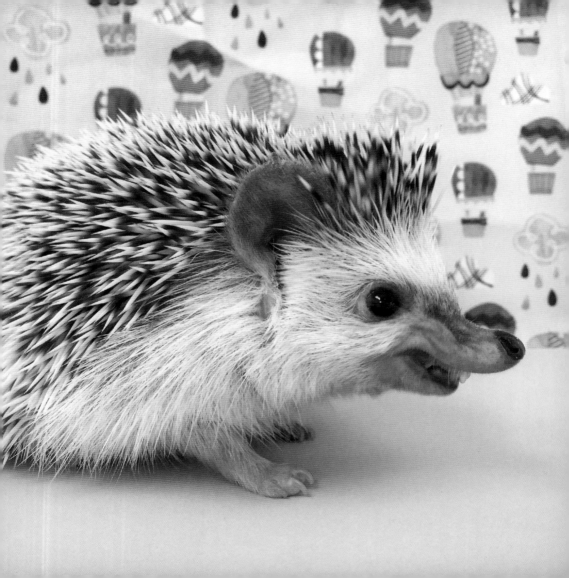

SMILING!

Smiling can be difficult for some people.

Like all difficult things, it takes some practicing!
If Huff can do it, so can you.

Affection

Hedge-hugs and hedge-kisses!

What is cuter than that?
Not a darn thing.

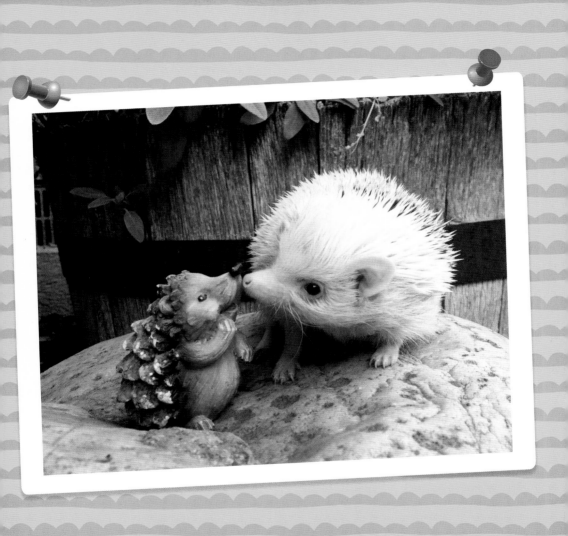

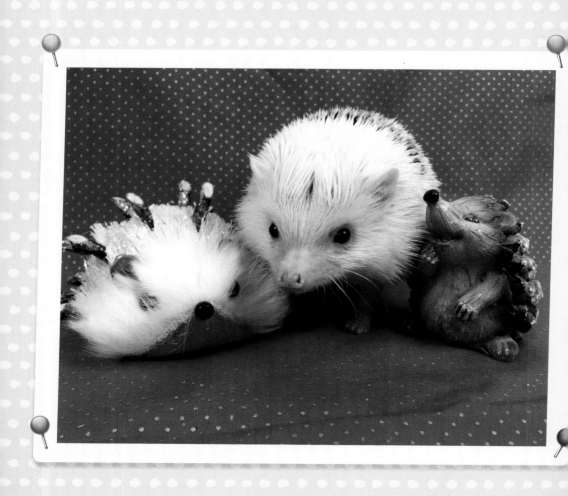

FAMILY

I've learned that the three most important words are not "I love you," but "I'll be there".

Even when you're a little prickly.

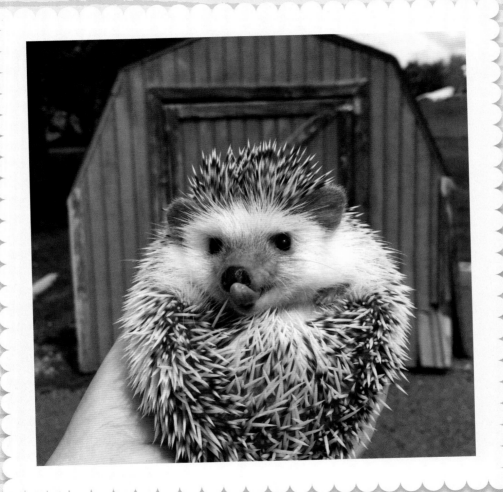

PETS AND ANIMALS

The smallest creatures usually have the biggest hearts. Open up yours and help an animal in need.

Check out your local animal shelter or rescue group!

Having a Place to Call Home

Home is where the hedgehog is.

Do try to clean it every now and then, though. Hedgehogs can be real hedge*pigs* sometimes.

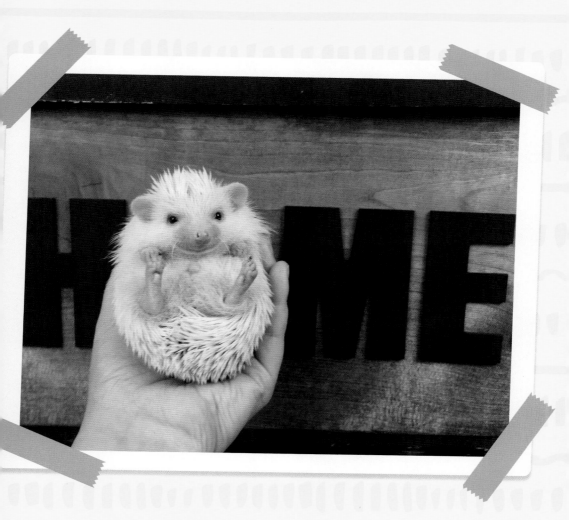

LOVE

Whether it is the love of a parent,
a partner, or a pizza . . . love is the
ultimate reason to smile. Spread love
with kind words!

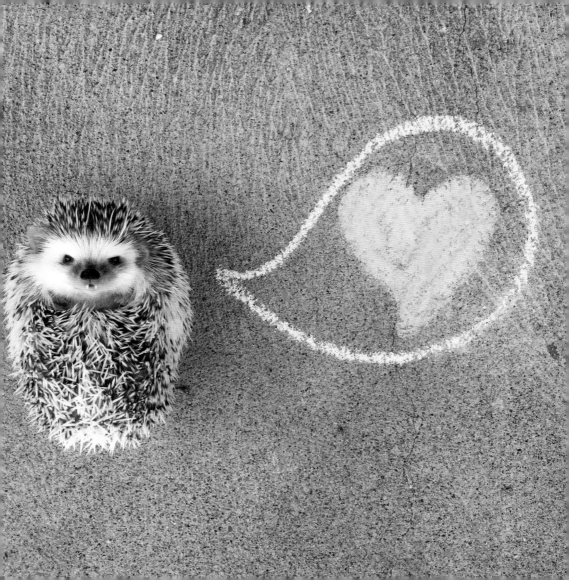

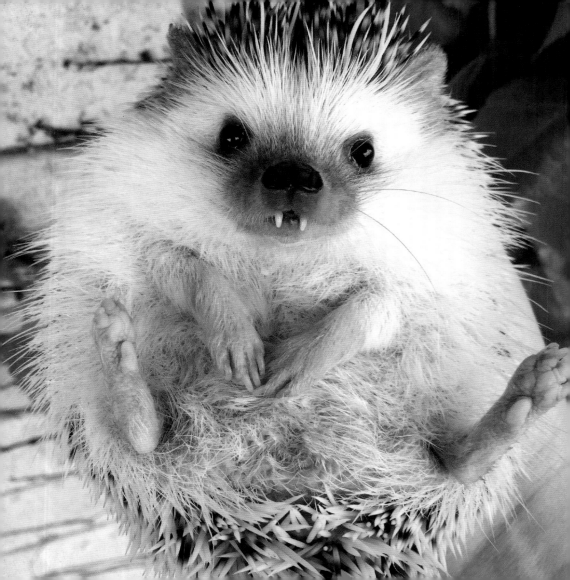

YOU!

Thank you for being one of my
little reasons to smile.

What Makes You Smile?

Is it a sunny summer day, or a cool autumn night?
Or a few hours alone with a good book? A healthy salad, or a big
slice of chocolate cake? Here's a place for you to write down those
little things that brighten your life and make you shimmy with joy!
